St Ives

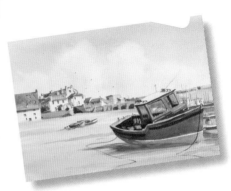

St Ives is a very popular holiday destination for millions of people, and you can easily see why. In this painting, a lovely jumble of buildings complements the boats beautifully.

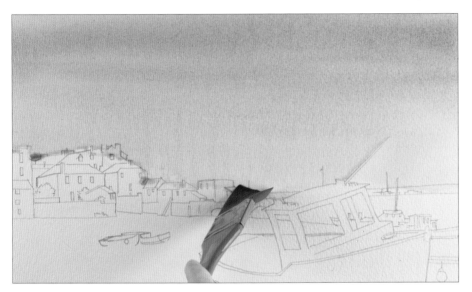

Tip

Draw the rigger over wet soap before applying the masking fluid. This will save your brush from being damaged by the masking fluid as it dries. Rinse out the brush quickly once the fluid is applied.

1 Transfer the image to the watercolour paper and secure with masking tape. Apply masking fluid to the masts with the size 3 rigger. Use the 38mm (1½in) wash brush to wet the sky above the roofline with clean water, and apply French ultramarine from the top down. Clean the brush and use it to lift away any beads that form.

2 Wash and remove the excess water from the brush, then use it to lift out clouds. Add a touch of light red to French ultramarine, and use this to add shading to the clouds. Finish the clouds with a touch of dilute yellow ochre added wet-into-wet to vary the colour. Use the 20mm (¾in) flat brush to lift out any paint on the buildings and horizon and allow the painting to dry.

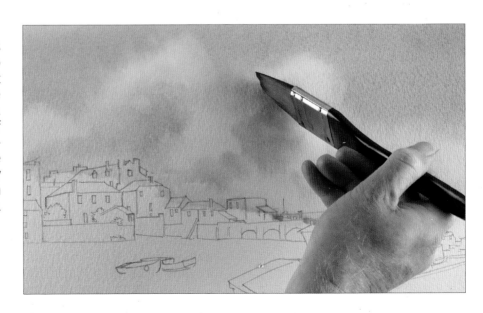

Tip

Be careful to leave a tiny sliver of dry white paper between each section of rooftop to avoid them bleeding together, and to keep them crisp.

3 Use raw umber with the size 8 round brush to paint in the rooftops in the background. As you advance, use dilute burnt sienna to paint lighter rooftops on the right-hand sides of the buildings.

4 Change back to raw umber to paint the shaded parts of the roofs on the left.

5 Mix yellow ochre and raw umber to paint the shaded sides of the buildings on the right.

6 Use a more dilute mix to paint the highlighted sides, then add raw umber to the wet (shaded) sides to add texture.

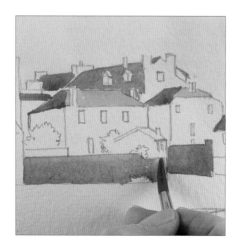

7 Still using the size 8 round brush, use raw umber and burnt sienna for the wall in front of the buildings. Add yellow ochre to the mix for the left-hand side of the wall, then lift a little out on the right as shown.

8 Add a touch of French ultramarine to the mix and block in the building on the left. As with the other buildings, paint carefully around the window areas.

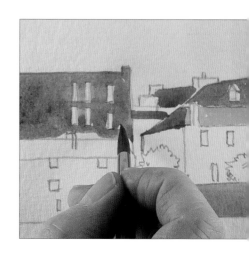

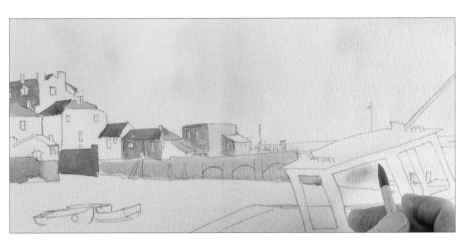

9 Wet the arched area and the background on the right, including the areas seen through the cabin of the boat. Carefully drop in yellow ochre to paint the areas.

10 Drop raw umber in wet-into-wet, then work some light red into the area to add interest and texture.

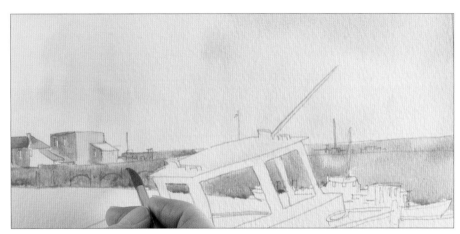

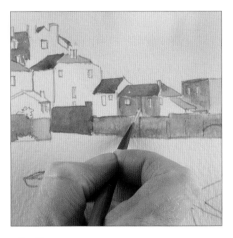

11 Clean your size 8 round brush and carefully use the tip to lift out the buttress on the wall. Allow the painting to dry.

Tip

When painting the windows, vary the style on different buildings to make the town look more varied and realistic. Try two boxes separated by a sliver of white paper.

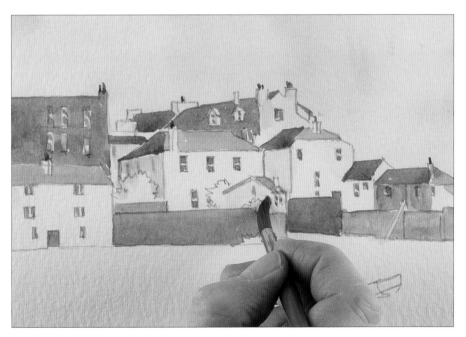

12 Paint the remaining buildings on the left with the same colours, then paint all of the windows with a mix of French ultramarine with a touch of light red. Touch in the door on the left with Hooker's green.

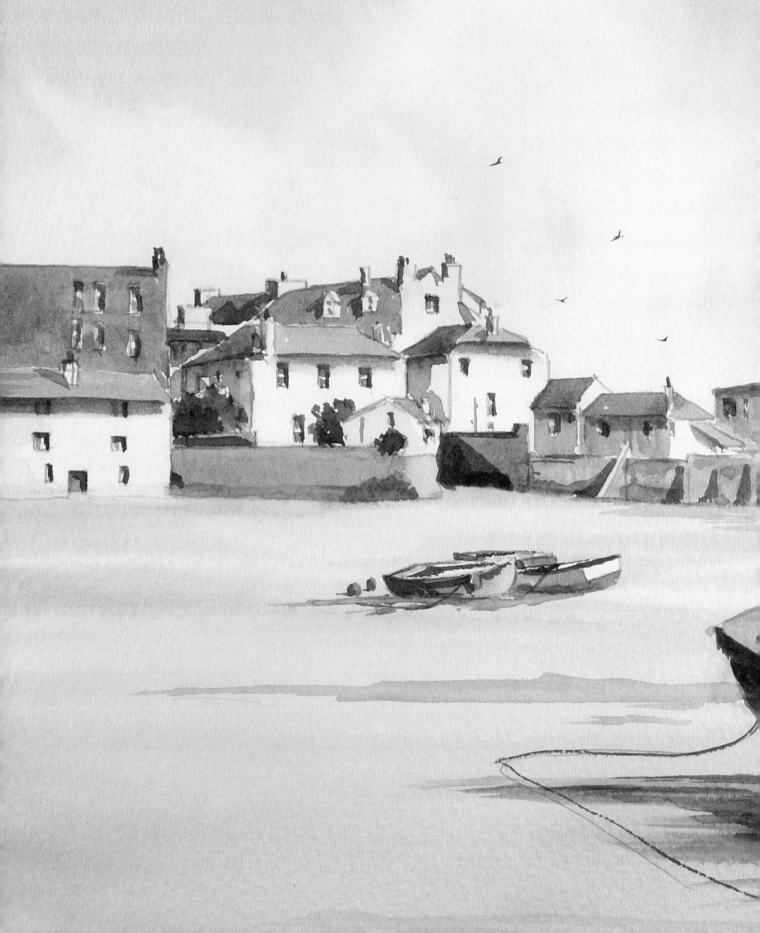

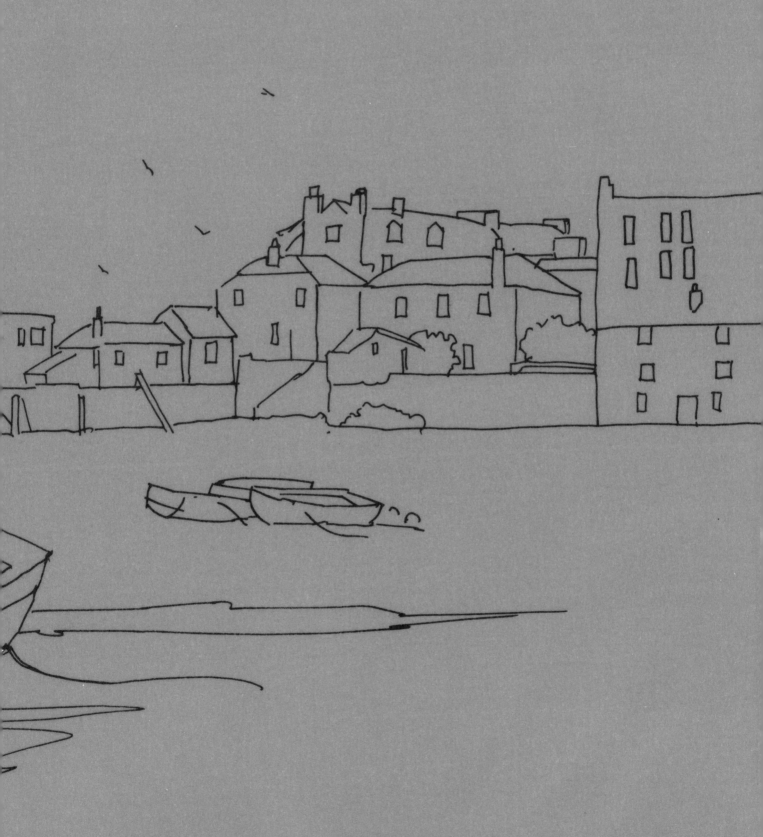

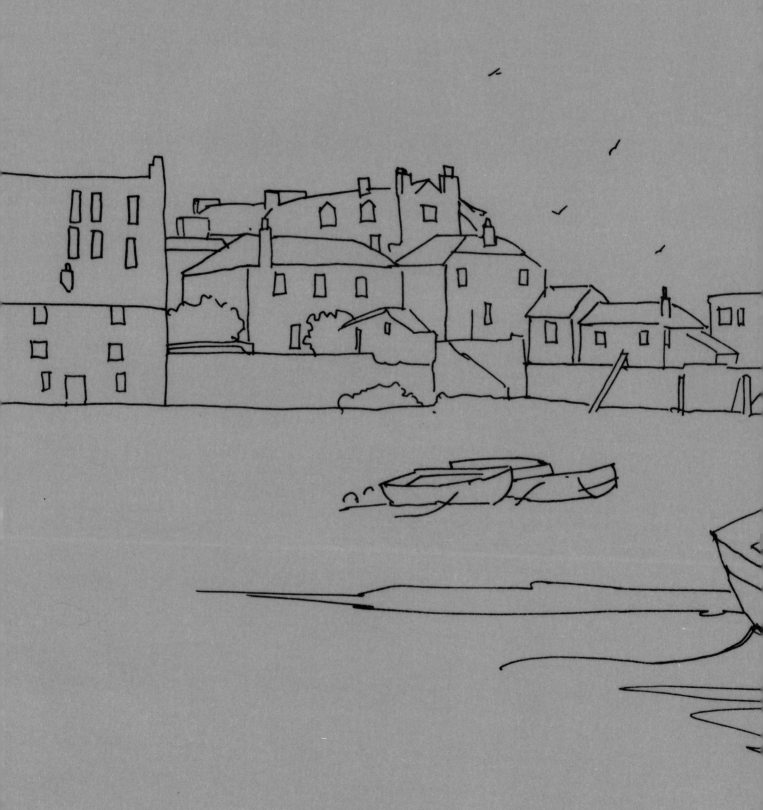

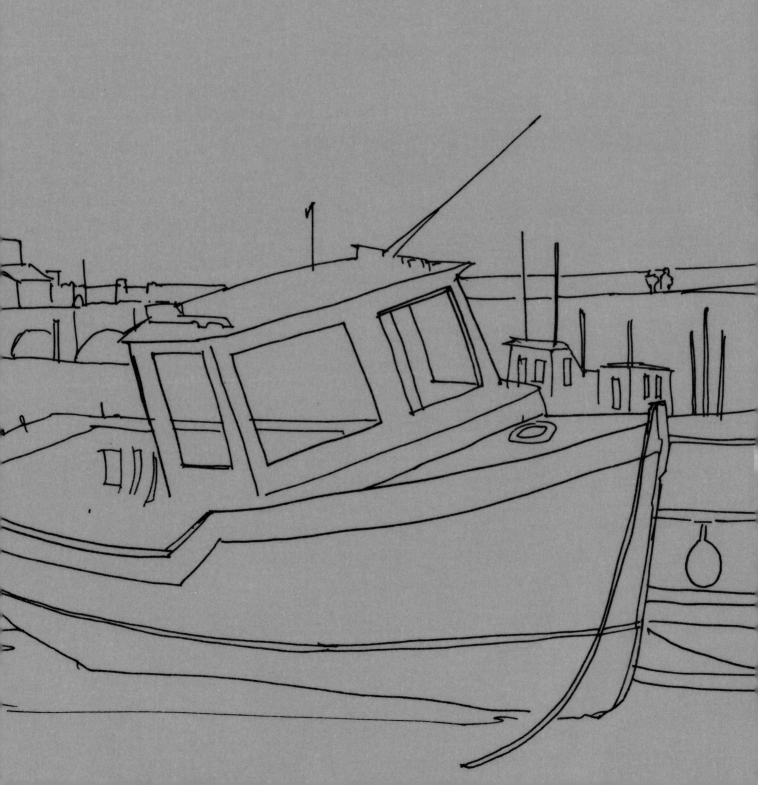

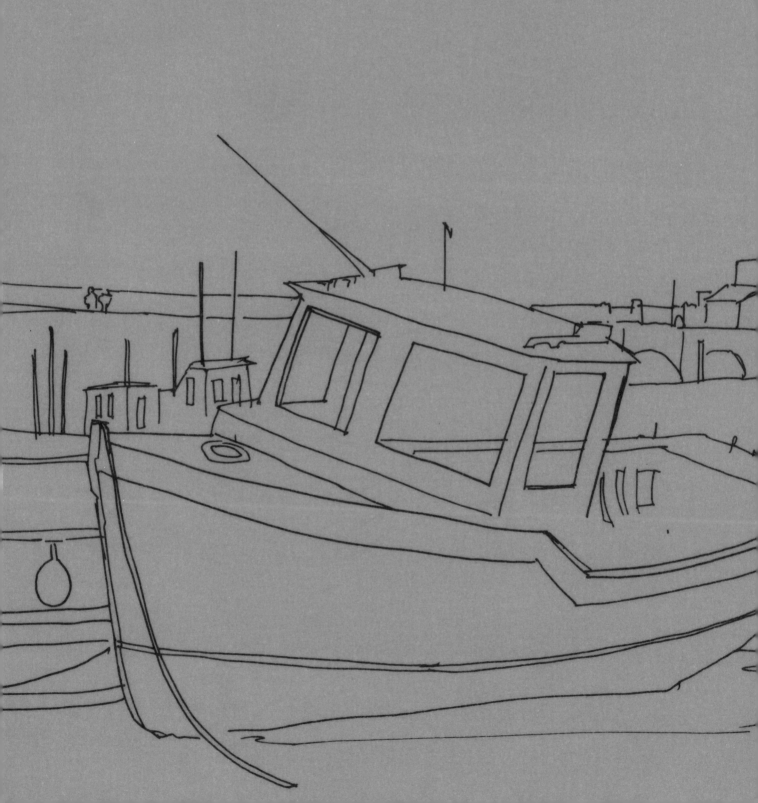

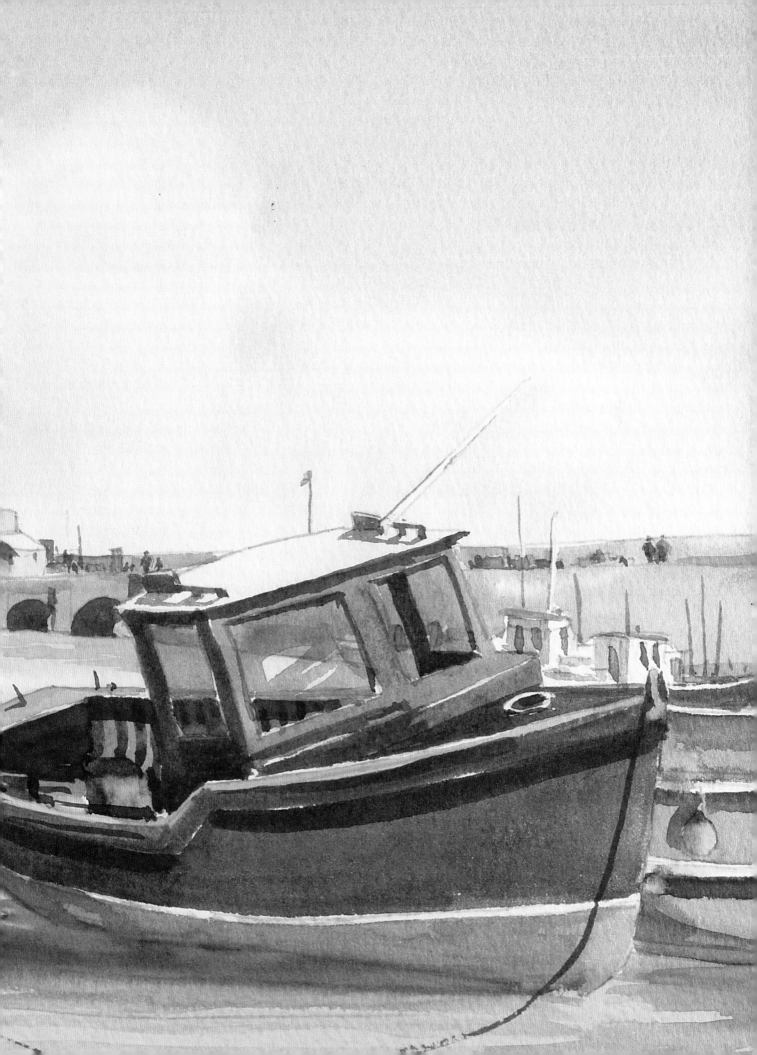

13 Make a shadow mix from French ultramarine, alizarin crimson and burnt sienna, and use it with the size 8 round brush to paint the shaded areas under the arches.

14 Add the shadow mix over the wall as shown. Work carefully, and work out where the shadows would fall in real life.

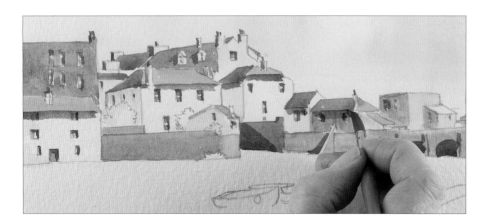

15 Recess some of the windows by edging the top and right-hand sides with the shadow mix, then run even lines of shadow beneath the rooftops.

16 Soften the shadows slightly with a touch of clean water, then add more French ultramarine to the mix and paint the remaining shaded areas of the buildings. Use a more dilute mix to add texture and interest to the buildings and walls, then allow the painting to dry completely.

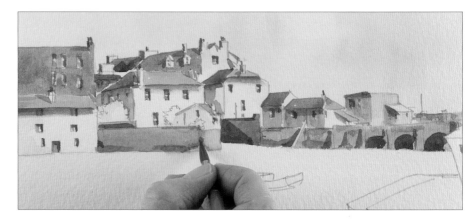

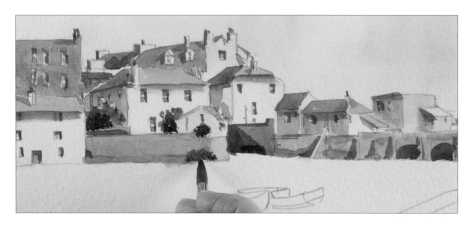

17 Use a mix of burnt sienna and Hooker's green to paint the trees. Leave a little clean paper at the top edges and use French ultramarine wet-into-wet to add shading and texture.

18 Still using the size 8 round brush, use French ultramarine to add some details for interest along the top of the wall. Vary the colour with touches of burnt sienna added wet-into-wet.

19 Add some dots of cadmium red just off-centre, then use light red, Hooker's green and a black mix of French ultramarine and burnt sienna to paint some figures on top of the wall on the right.

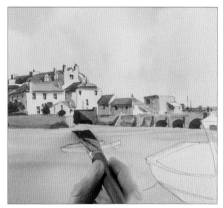

20 Wet the beach with clean water using the 20mm (¾in) flat brush, being careful to leave the boats clean and dry. Use a mix of yellow ochre, raw umber and a touch of French ultramarine to paint the beach, using a slightly less dilute mix as you advance.

21 Working wet-into-wet, add touches of light red and then yellow ochre to the sand area to add texture, interest and shading.

22 Add a touch of light red to French ultramarine, then apply wet-into-wet to the beach. Clean the brush, and use the edge to lift out some areas with horizontal strokes. Allow the painting to dry.

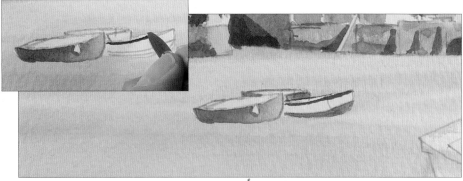
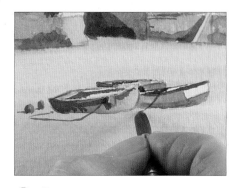

23 Use the size 8 round brush with cobalt blue to paint the left-hand boat below the buildings, lifting out a little on the right-hand side. Paint the top of the boat to the right with the same colour (inset), then use light red to paint the bottom, and a mix of cobalt blue with a touch of Hooker's green for the last boat in the group.

24 Use a mix of cadmium red and yellow ochre to paint the buoys, then make a black mix of French ultramarine and burnt sienna for the insides and details of the group of boats. Use the same black mix for the mooring ropes.

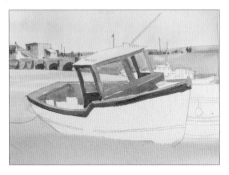

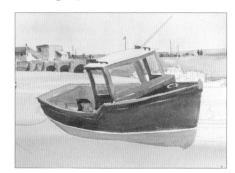

25 Make a mix of raw umber and burnt sienna, and use to block in the main parts of the main boat as shown. Use a more dilute mix to paint the areas in the light and the top of the gunwale. Leave some white spaces for cargo as shown.

26 Paint the hull of the boat and the front deck with a mix of French ultramarine and burnt sienna. Once dry, paint the bottom of the hull with light red. Do not leave a sharp, even edge: paint a curve to make the boat look embedded in the sand.

27 Paint some of the cargo with the French ultramarine and burnt sienna mix, and some with a light red and yellow ochre mix. Paint the details on the roof with the lighter mix, then lift out some of the colour from of the cargo with a little clean water.

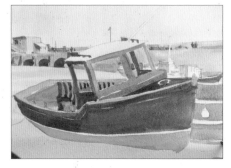

28 Make a mix of raw umber, burnt sienna and a touch of French ultramarine. Still using the size 8 round brush, detail the inside of the boat. Allow to dry, then rub off all of the masking fluid from the painting using a clean finger (see inset).

29 Use dilute cadmium red, cobalt blue and a mix of cobalt blue and Hooker's green to paint the boats on the right. Use light red to paint the bottom hull of the lowest boat as shown. Use a dilute mix of French ultramarine and burnt sienna to paint the background boats.

30 Paint the buoy on the red boat with a mix of cadmium yellow and cadmium red, then shade with the black mix (French ultramarine and burnt sienna). Dilute the black mix, and use it to shade and detail the background boats, and add windows and aerials to the wheelhouse.